BACKYARD HUNTER
The Praying Mantis

text and photographs by

BIANCA LAVIES

E. P. DUTTON · NEW YORK

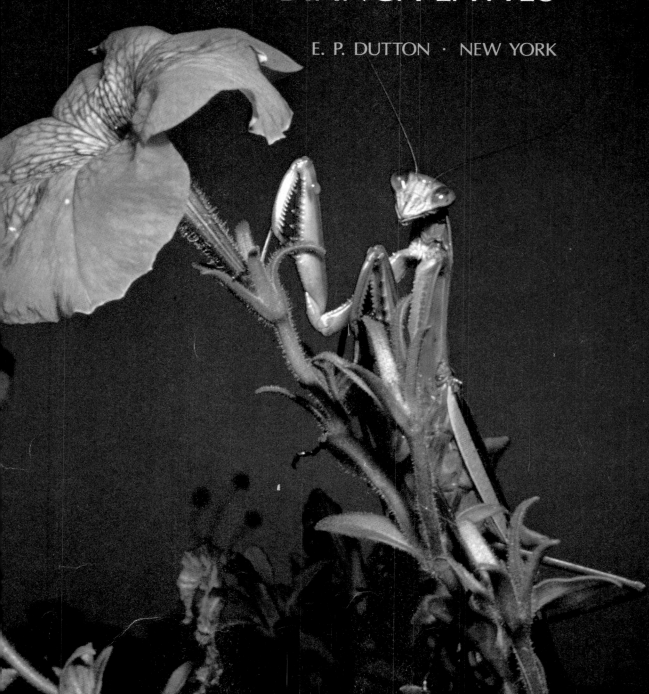

ACKNOWLEDGMENTS

for sharing time and knowledge:
Dr. William Shear, Hampden-Sydney College
Dr. David Nickle, Systemic Entomology Laboratory, National Museum
 of Natural History, Smithsonian Institution, Washington, D.C.

Library of Congress Cataloging-in-Publication Data

Lavies, Bianca.
 Backyard hunter: the praying mantis/text and photographs
by Bianca Lavies.—1st ed.
 p. cm.
 Summary: Describes the physical characteristics, behavior, and
life cycle of this insect that eats other insects alive.
 ISBN 0-525-44547-1
 1. Praying mantis—Juvenile literature. [1. Praying mantis.]
I. Title. 89-37485
QL508.M4L58 1990 CIP
595.7'26—dc20 AC

Published in the United States by E. P. Dutton,
a division of Penguin Books USA Inc.

Published simultaneously in Canada by
Fitzhenry & Whiteside Limited, Toronto

Designer: Kathleen Westray

Printed in Hong Kong by South China Printing Co.
First Edition 10 9 8 7 6 5 4 3 2 1

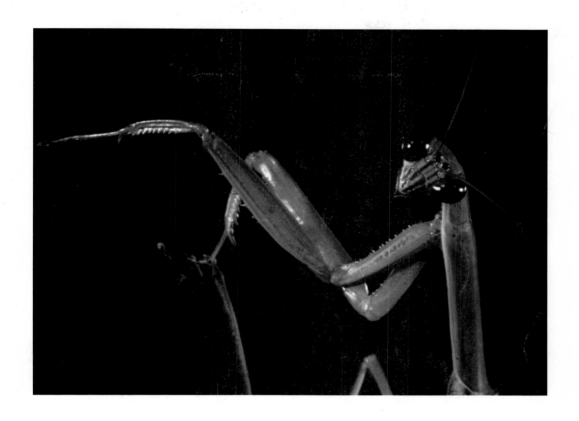

To Donna:

I photographed this book
especially for you, because
you liked them as a child.

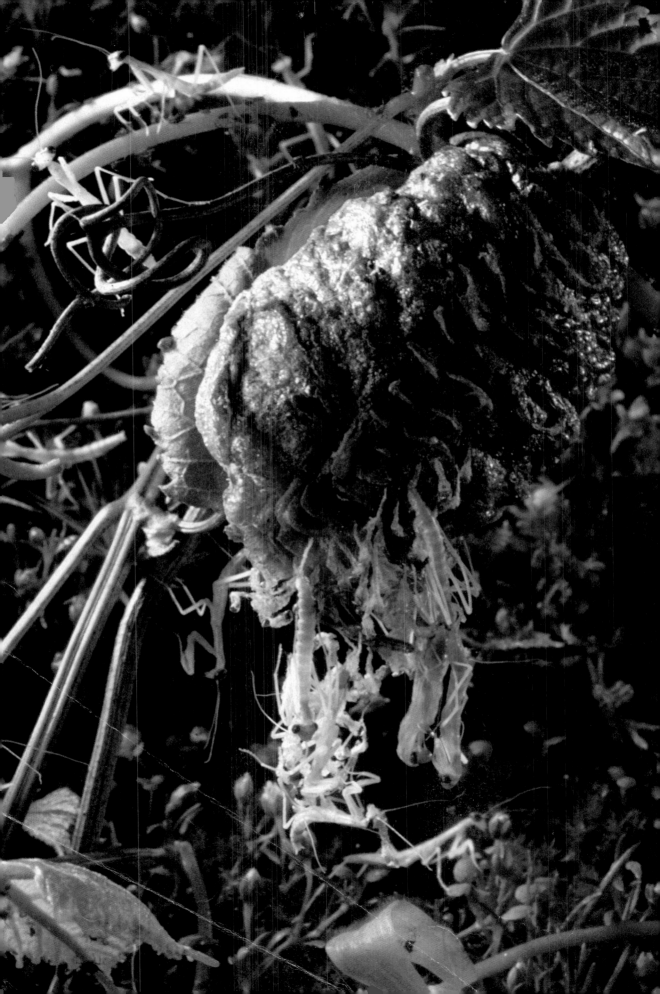

On a warm June day, in a backyard garden, an egg case is bursting with life. Praying mantises are hatching.

Last fall, they were just eggs inside the case. Cold winds blew. Snow and rain fell. Through it all, the eggs remained safe. And when warm weather came, they began to grow. Now hundreds of praying mantises are squeezing out of slits in the bottom of the case.

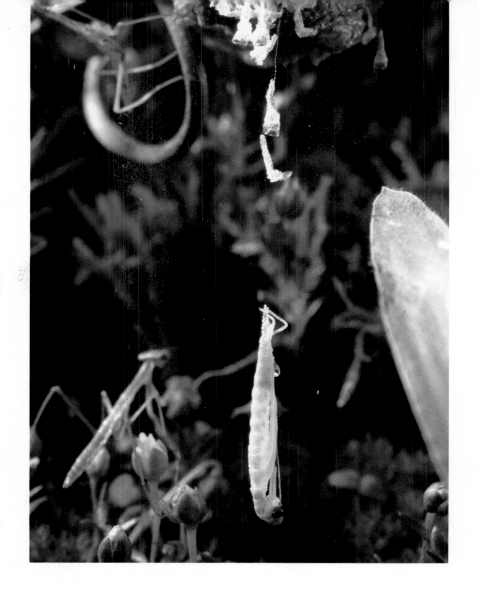

 Once they are out, the newly hatched mantises wriggle free of the thin sacs that protected them as they grew. They dangle upside down from the remains of the sacs. Though they are only as tiny as mosquitoes, they are already too big for their skins. So they slip out of them and wait about an hour for new skins underneath to harden. Then they set off into the garden to look for food.

 Praying mantises do not suck nectar from flowers, as bees and butterflies do. Nor do they eat green plants, as grasshoppers and some beetles do. Praying mantises eat other insects—alive! Within a few hours, many of these young mantises will even eat one another.

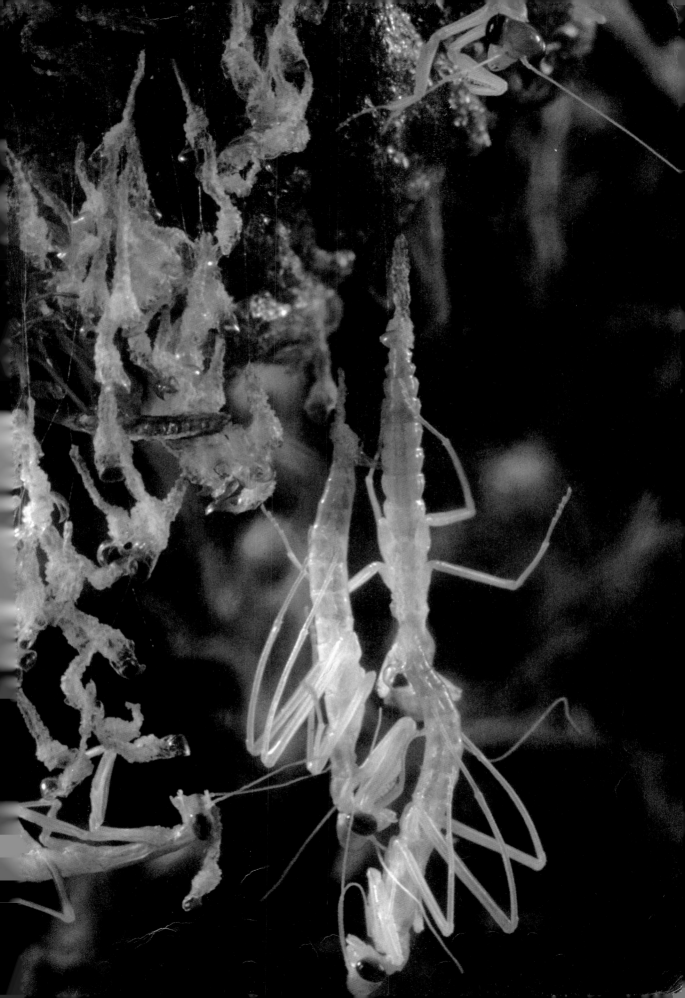

This mantis, only a few hours old, has found a clover leaf to stand on. Like all insects, it has two antennae and three pairs of legs. In a few months, it will develop two pairs of gauzy wings.

The mantis holds its two front legs as though it were praying. That is where it gets its name. But the praying mantis is not saying its prayers. It is just tucking those legs out of the way, waiting for a small insect to come by. Then it will reach out and snatch the insect for a meal.

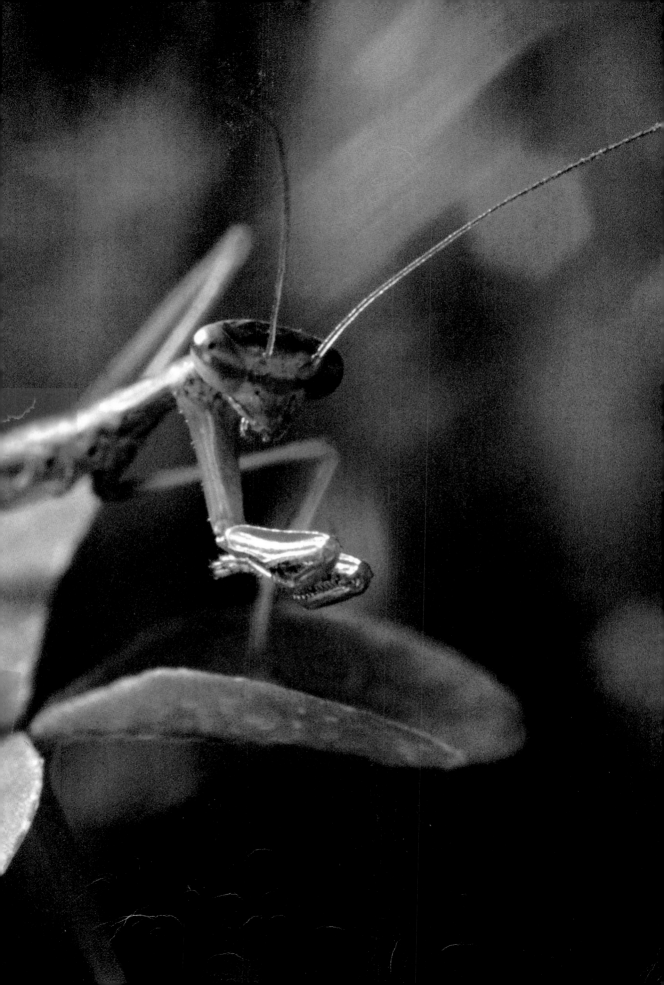

As a praying mantis grows, it sheds its skin, or molts, hanging upside down from a twig or a branch. It does this from six to nine times, depending on how much it eats.

This inch-long skin was shed after one month. It covered the mantis everywhere—legs, body, even the two antennae on its head. The empty skin almost looks like a real praying mantis.

The skin of a praying mantis is actually its skeleton. It gives the mantis support. If you picked up a mantis, its skin would feel hard, smooth, and waxy.

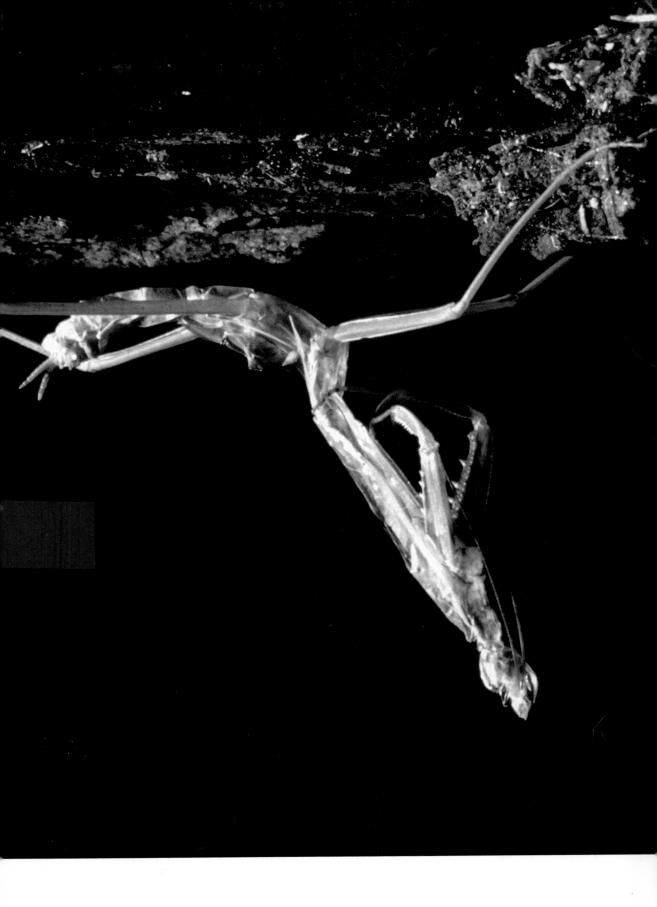

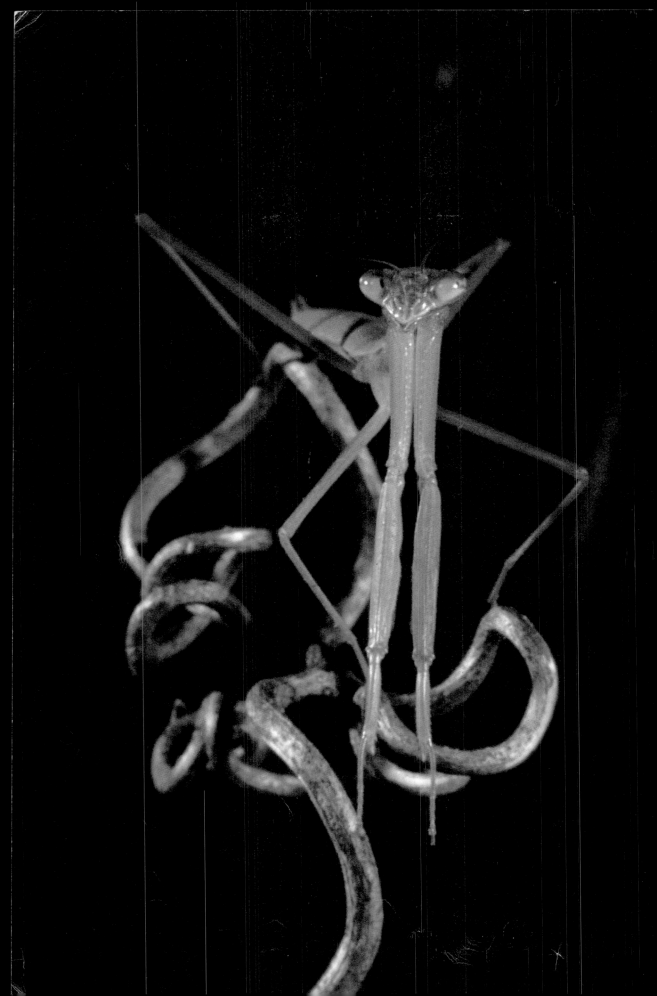

As praying mantises molt, their colors darken to brown or green. This month-old green mantis has been walking along a grape tendril. In a moment it will tuck its forelegs into the praying position and wait for a meal. But the grasshopper it sees is too big for it to eat. The mantis is only an inch long now. When it is older and larger, it will eat many grasshoppers.

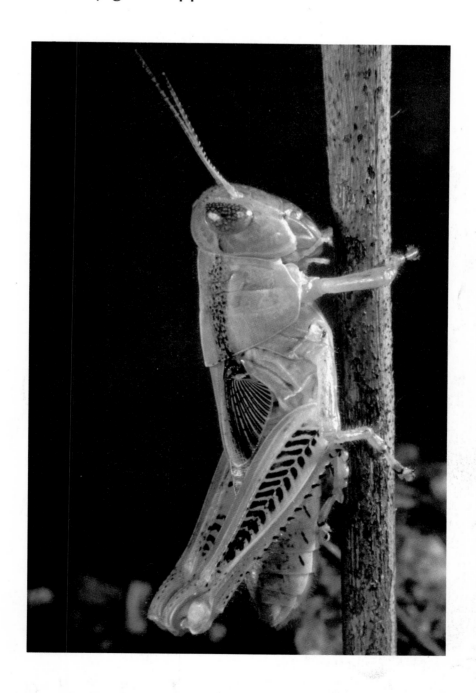

The mantis finds something else—a skin the grasshopper shed. But the empty skin is only worth a nibble.

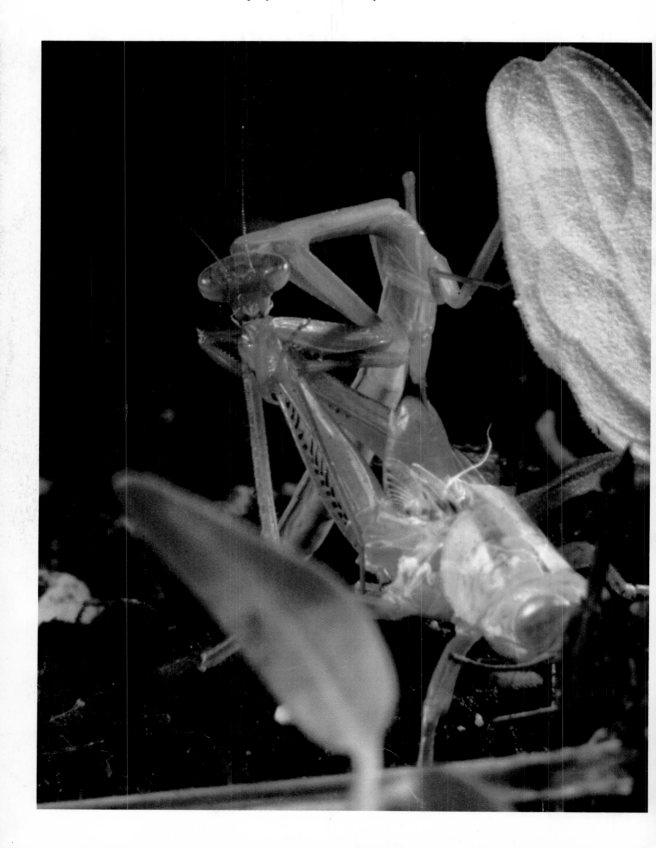

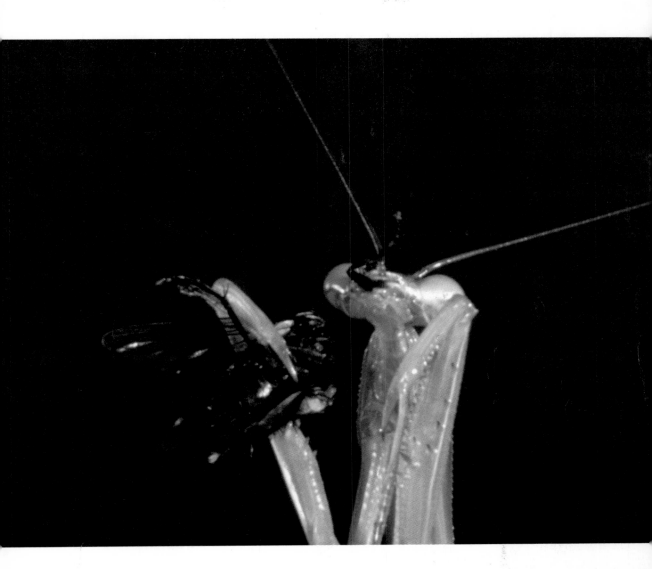

When a small fly lands nearby, the mantis snatches it faster than you can see. Now it has a meal.

Although a praying mantis can walk, leap, and even fly once its wings develop, it does not chase its food around the garden. It sits still and waits, blending in with leaves, grass, and twigs. Sometimes it must wait a long time for a smaller insect to come within striking range.

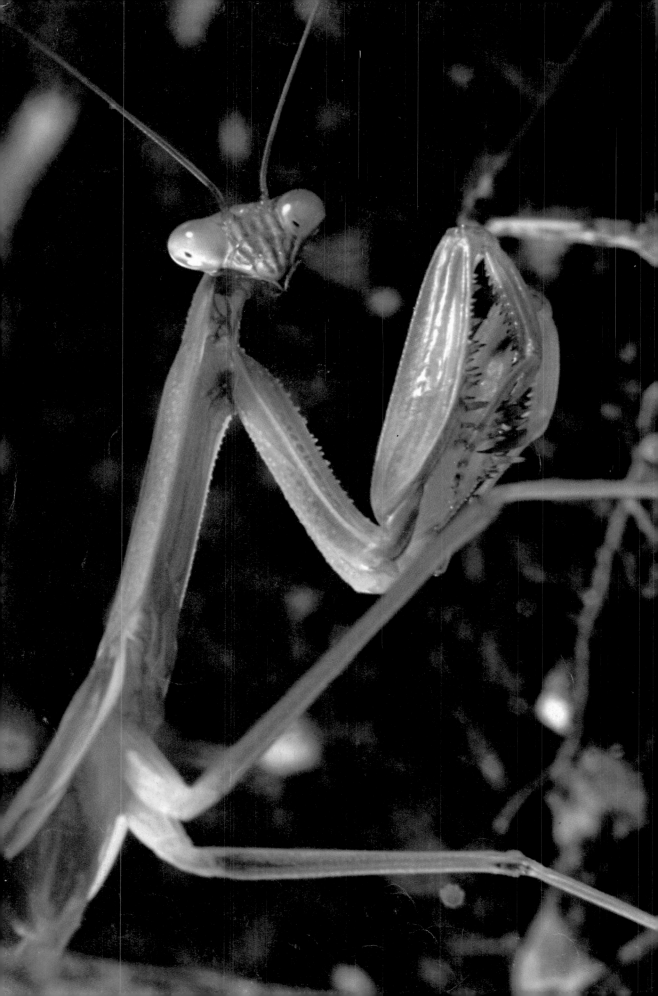

About two months after hatching, a praying mantis begins to develop wings. This brown mantis is now two inches long. Midway down its back, wings have started to form.

Its spiny front legs are large and powerful. They can pierce and hold a wiggling cave cricket while the mantis eats it.

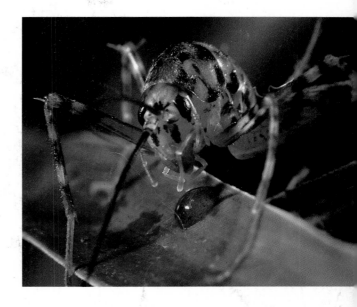

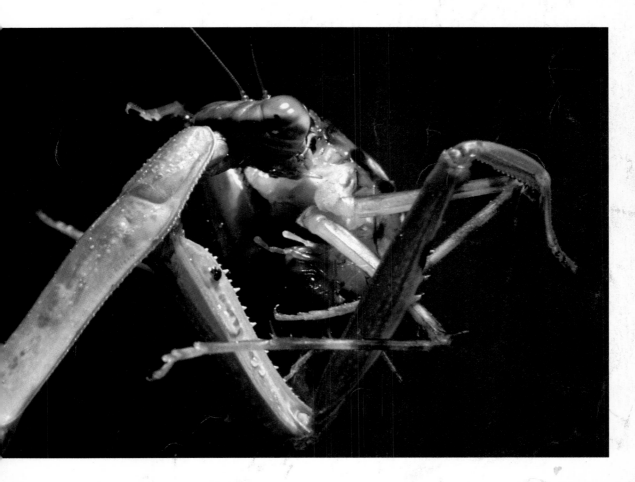

After it eats, the praying mantis grooms itself. First it cleans every part of its front legs. Then it cleans every part of its head, using first one front leg and then the other. It runs each leg around its head, through its mouth, and back over its head—sort of the way a cat does. The mantis needs to keep its eyes and antennae clean—they help it find food.

This praying mantis, and all the others that hatched from the egg case in June, are Chinese mantises. Chinese mantises were brought to the United States about ninety years ago, perhaps by boat, perhaps by accident. No one knows for sure.

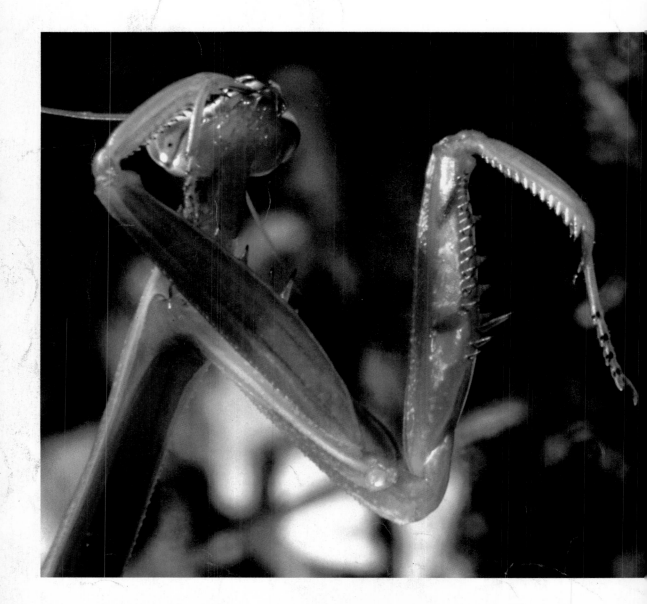

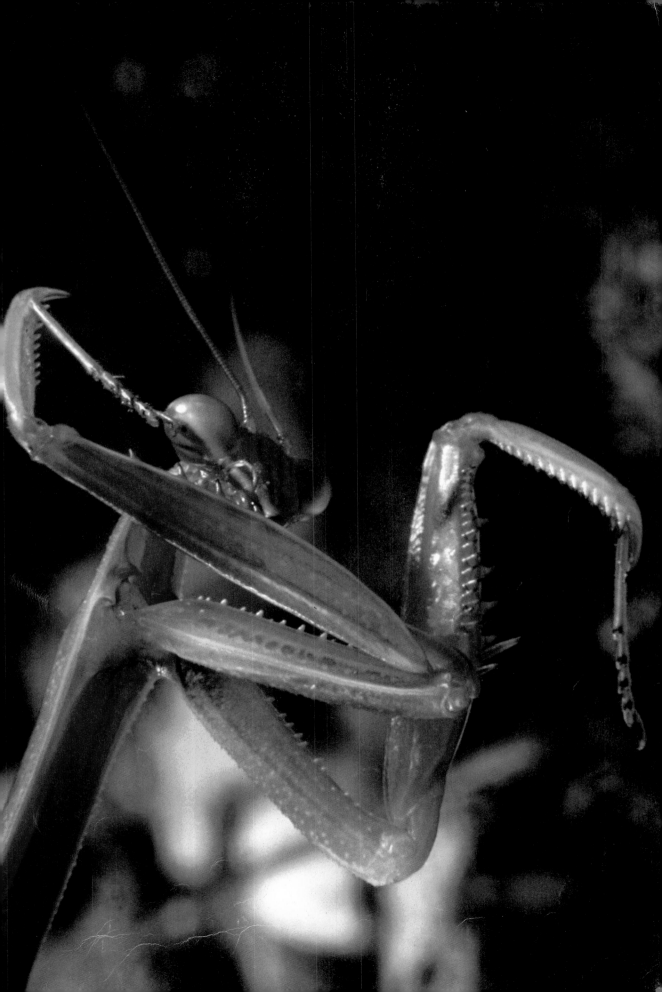

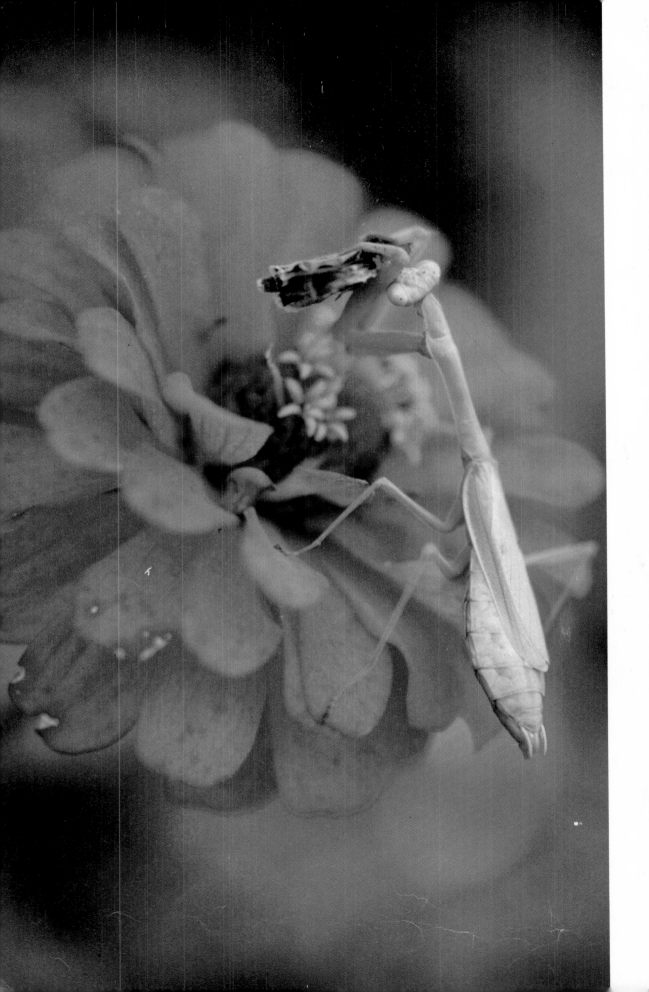

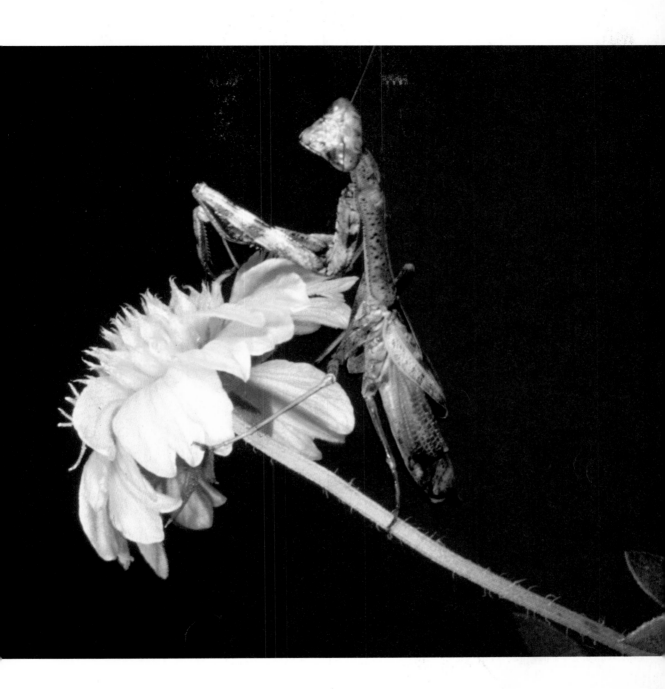

These two praying mantises are Carolina
mantises. They are native to the United States
and are smaller than Chinese mantises. The
one on the red flower has caught a butterfly.
The other is still waiting to snatch a meal.

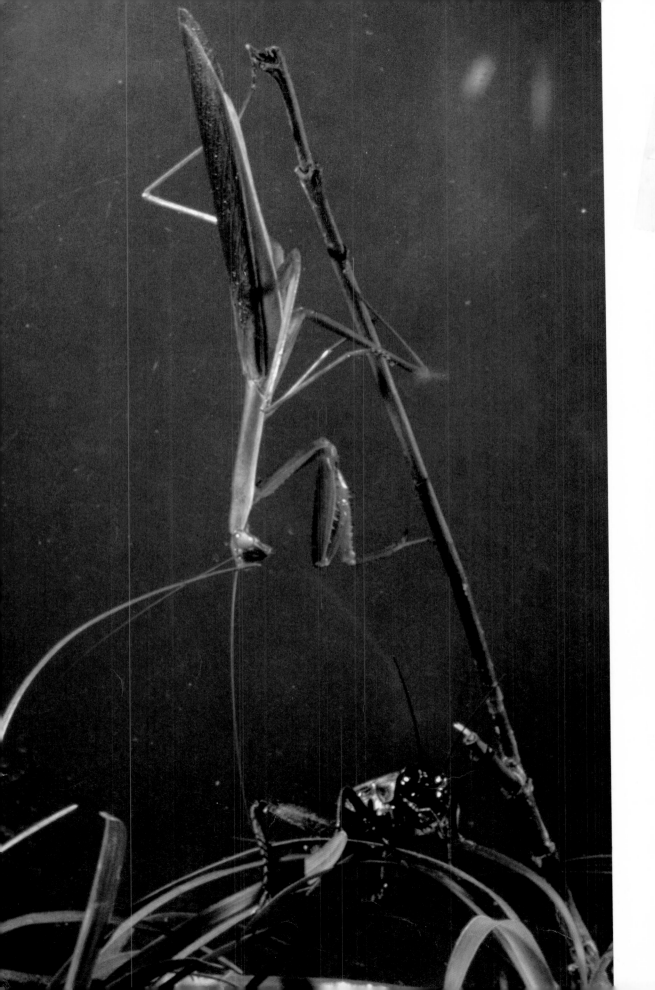

It is September, and this male Chinese mantis has shed his skin for the last time. His final molt exposed fully grown wings, folded down his back. Now he can fly.

Praying mantises hunt for insects during the day, evening, and at night. Many insects have rest periods, but mantises appear to be alert at all hours.

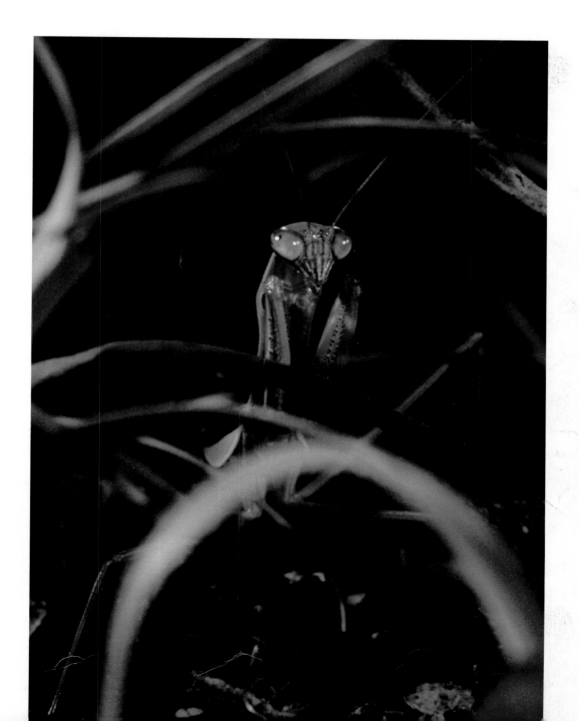

This female is also full-grown. She is larger than the male, and her abdomen is full of eggs. She used to be a good flyer, but now the eggs make her too heavy.

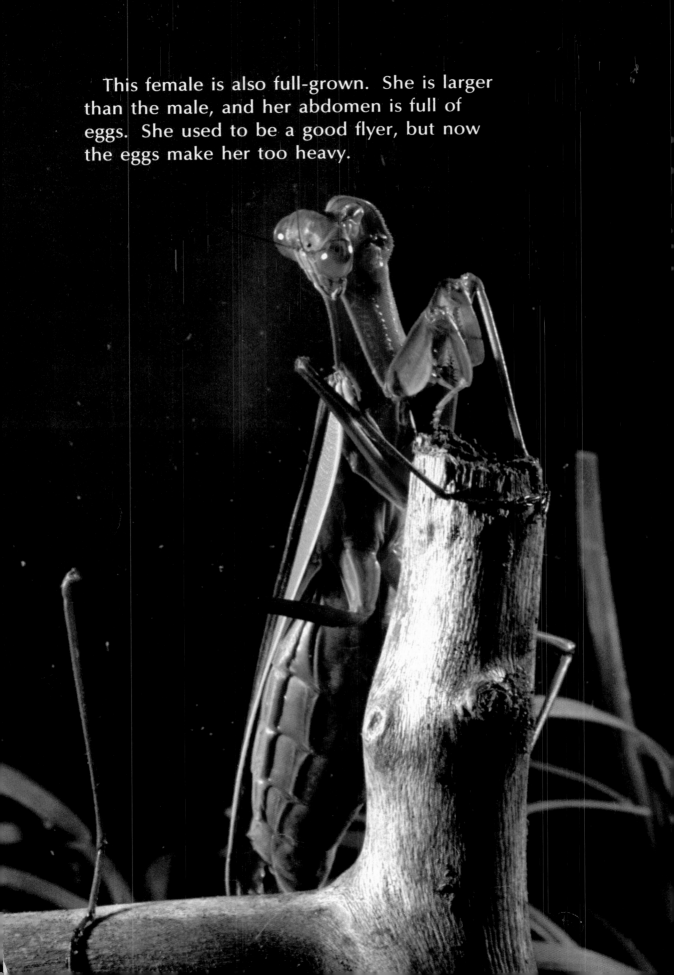

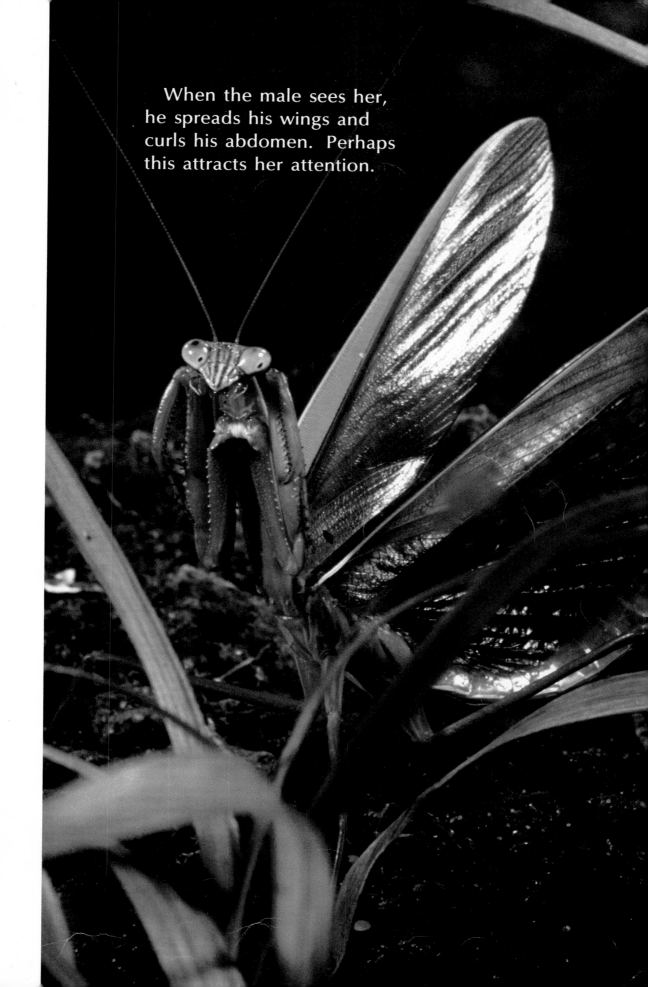

When the male sees her,
he spreads his wings and
curls his abdomen. Perhaps
this attracts her attention.

The female extends her front legs as the
male comes near. She may do this to show
the male she won't attack him.

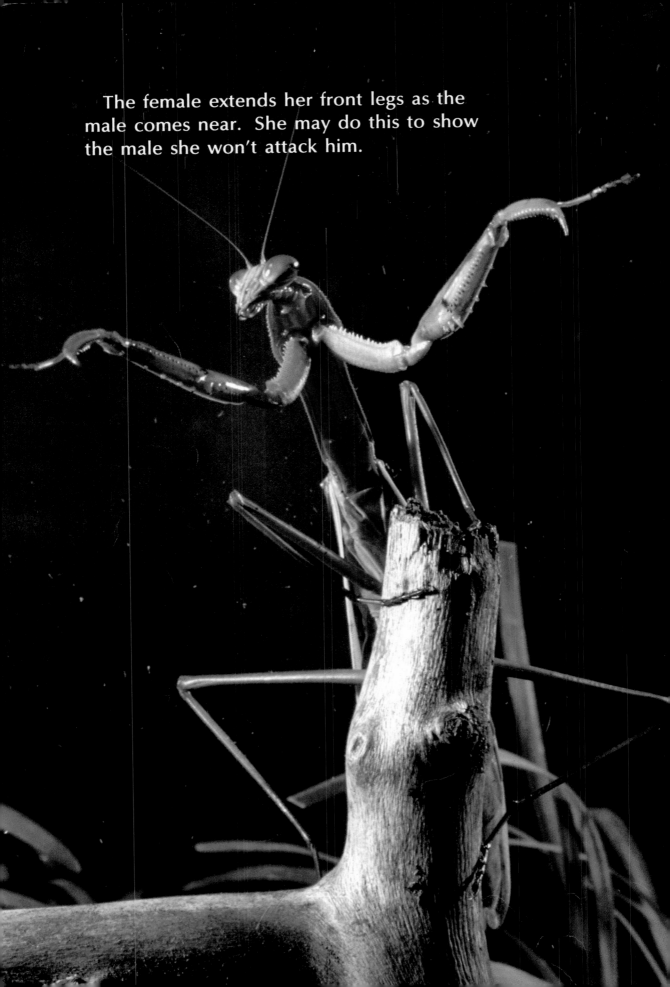

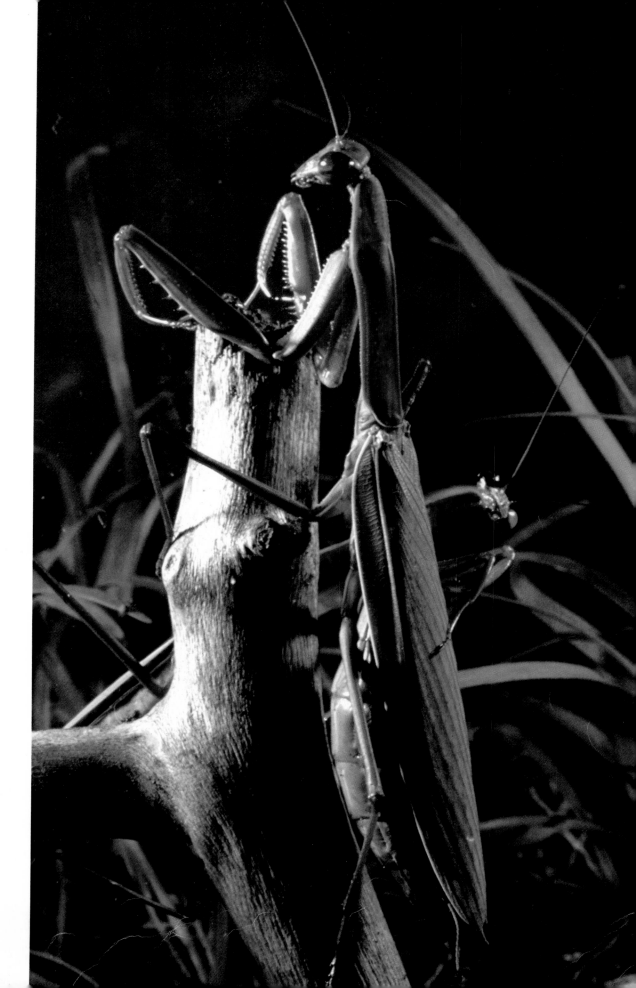

The male climbs onto the female's back and stays there for about five hours. He donates sperm to her, which she stores in a special place inside her body.

When the mating is over, the male will take a sudden flying leap away. Perhaps this big leap ensures that the female won't eat him. Female mantises have been known to eat their mates when they haven't had any food for a long time.

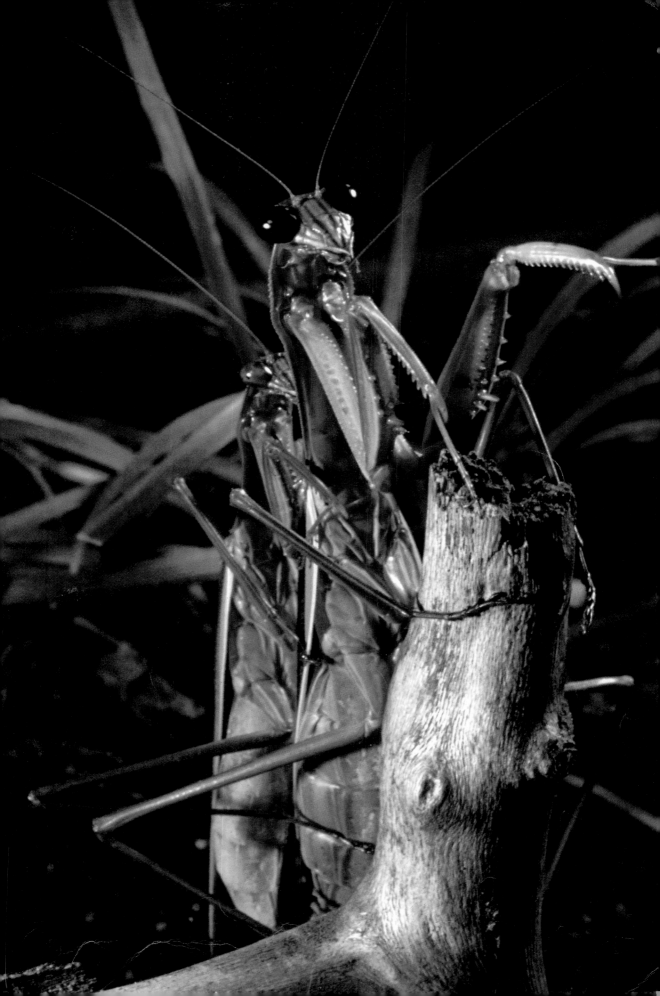

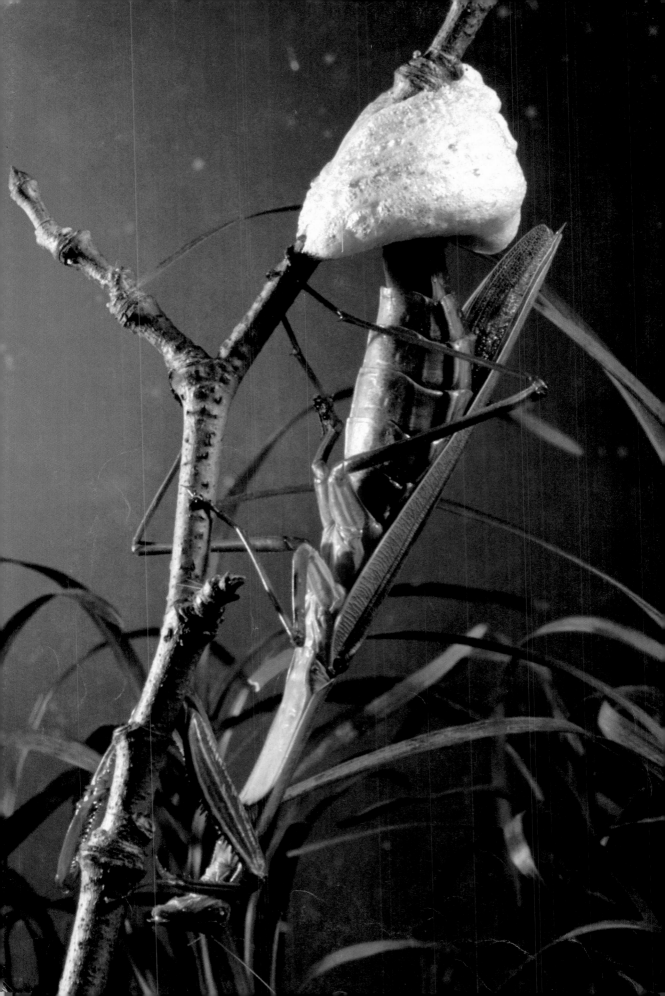

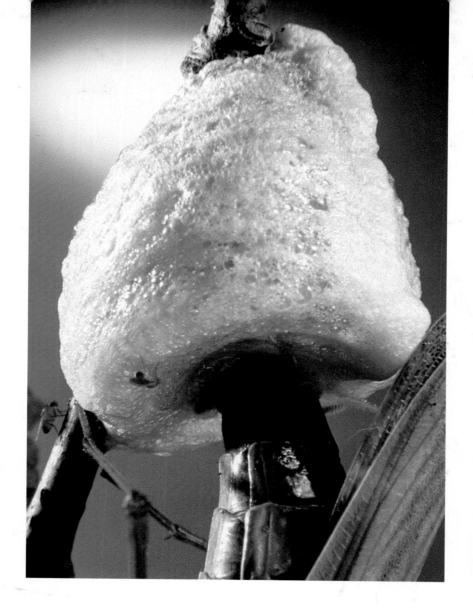

About nine days later, the female makes her first egg
case. She hangs upside down on a twig, and foam flows
from the end of her body. Her abdomen moves in
circles as she works. As she lays eggs in the foam, she
covers them with some of the stored sperm. When it is
finished, the egg case is about the size of a walnut.

Small flies investigate it.

The soft sticky foam soon hardens. After several days,
it darkens from white to tan. The female will make
several more egg cases with the rest of the stored sperm,
and she may mate again.

As the days get shorter and colder, there are fewer and fewer insects for the praying mantis to eat. She will not live much longer. But her egg cases will survive. Through snow, wind, and rain, through winter and spring, they will hang on twigs in the garden, protecting the eggs inside.

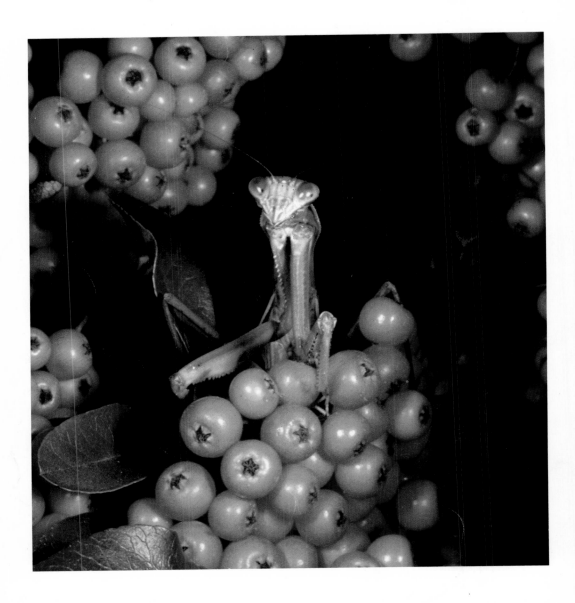

And in June, when summer comes and the days are warm, backyard hunters will hatch again.